Tim Crouch's A

'You will see no false nothing false tonight'
— the Hypnotist

Tim Crouch's second play collapses a tale of loss and grief into an exploration of theatrical representation, in a piece of theatre that is at once formally innovative and profoundly moving. Written for two actors, *An Oak Tree* depicts the fraught meeting of a grieving father and the stage hypnotist who was behind the wheel of the car that killed his daughter, with the father played by a different actor at each performance, walking on stage with no prior knowledge of the play.

Catherine Love explores *An Oak Tree*'s connections with conceptual art, the unique process of its creation, its interrogation of stage representation, its relationship with audiences, and its place as part of Crouch's ongoing body of work.

Catherine Love is currently completing a thesis on the status of the text in contemporary English theatre at Royal Holloway. She is the editor of the student edition of *Punk Rock* by Simon Stephens and she also writes for *The Guardian*, *The Stage* and *Exeunt*.

The Fourth Wall

The Fourth Wall series is a growing collection of short books on famous plays. Its compact format perfectly suits the kind of fresh, engaging criticism that brings a play to life.

Each book in this series selects one play or musical as its subject and approaches it from an original angle, seeking to shed light on an old favourite or break new ground on a modern classic. These lively, digestible books are a must for anyone looking for new ideas on the major works of modern theatre.

Also available in this series:

Coming soon:

Tim Crouch's *An Oak Tree*

Catherine Love

Routledge
Taylor & Francis Group

LONDON AND NEW YORK

First published 2017
by Routledge
2 Park Square, Milton Park, Abingdon, Oxon OX14 4RN

and by Routledge
711 Third Avenue, New York, NY 10017

Routledge is an imprint of the Taylor & Francis Group, an informa business

British Library Cataloguing-in-Publication Data
A catalogue record for this book is available from
the British Library

Library of Congress Cataloguing-in-Publication Data
Names: Love, Catherine, author.
Title: Tim Crouch's An oak tree / Catherine Love.
Description: Abingdon, Oxon; New York, NY: Routledge, 2017. |
Series: Fourth wall | Includes bibliographical references.
Identifiers: LCCN 2016057690 | ISBN 9781138682825 (pbk.) |
ISBN 9781315521572 (ebook)
Subjects: LCSH: Crouch, Tim, 1964– Oak tree.
Classification: LCC PR6103.R67 O3557 2017 |
DDC 822/.92–dc23 LC record available at
https://lccn.loc.gov/2016057690

ISBN: 9781138682825 (pbk)
ISBN: 9781315521572 (ebk)

Typeset in Bembo
by Out of House Publishing

Whether Mr. Mutt with his own hands made the fountain or not has no importance. He CHOSE it. He took an ordinary article of life, placed it so that its useful significance disappeared under the new title and point of view – created a new thought for that object.

– Roche *et al.* 1917: 5

Contents

Acknowledgements

I would like to thank Ben Piggott and Routledge for encouraging me to pursue my enthusiasm for *An Oak Tree* and for supporting me throughout the process of producing this book. Thanks must also go to Dan Rebellato for his ongoing advice and guidance. I am grateful to Tim Crouch for his generosity in discussing his work over the years and for the play that inspired the following pages. Finally, a special thanks to Mark Smith for his support in everything (and for his brilliant proofreading).

Introduction

All theatre has those moments when something doesn't quite go to plan. The actor fluffs their lines. The lighting cue is a moment late. Something – or someone – falls over. Briefly, the representational machine stutters. We see the cogs turning.

Watching *An Oak Tree* in the National Theatre's temporary theatre in July 2015, one such moment interrupts the performance. Conor Lovett, the unrehearsed second actor being led through the performance step by step, responds to Tim Crouch's words 'you're doing really well' by saying 'So are you' (Crouch 2015b: 56). He's reading, very visibly, from a script in his hands. On this night, though, a swell of laughter from the audience interrupts his next line. Crouch, grinning, turns to address us. 'There's a funnier line coming up next,' he says. He's right: Lovett, recovering, tells Crouch 'It's really well written' (*Ibid.*).

What's going on here? Both Crouch and Lovett are playing more than one role at once. Crouch is simultaneously playing a version of himself, the author of the play we are watching, and

the role he has written himself into: a second-rate stage hypnotist who is haunted by the guilt of killing a young girl in a road traffic accident. Lovett, likewise, is appearing on stage both as himself and as the second character in the narrative: the father of the dead girl. In this little exchange, Crouch is 'Crouch' and Lovett is 'Lovett'. They appear to be talking spontaneously about the performance they are enacting for us – or at least they *would* appear to be, were it not for the conspicuous presence of the script. But then, interrupting the faked ad libs, is a real ad lib. We can no longer be quite sure what's scripted and what's not.

This is, on one level, a gag. Crouch wants the audience to realise that he has scripted praise of his own play, making a joke at the expense of his ego. At the same time, though, this short scene is exemplary of the ways in which *An Oak Tree* – and Crouch's theatre more broadly – lays bare the mechanics of theatrical representation and meaning-making. Thanks to the use of the script as a prop throughout this exchange, Crouch underlines the slippages between text and performance that are present in any piece of theatre, as well as the multiple acts of transformation that theatrical performance necessarily entails.

The idea of transformation is central to *An Oak Tree*. The piece, which was first staged in 2005, was inspired by and named after Michael Craig-Martin's 1973 artwork *An Oak Tree*, which consists of simply a glass of water on a shelf and an accompanying piece of text on the wall of the gallery. Using the playful form of a Q&A, the text explains that what Craig-Martin has done is 'change a glass of water into a full-grown oak tree without altering the accidents of the glass of water'. The text elaborates: the glass of water is not a symbol of an oak tree and nor has its appearance changed in any way. 'The

actual oak tree is physically present but in the form of the glass of water' (Craig-Martin 1973).

Crouch has described Craig-Martin's work as 'the most important piece of theatre writing I know' (Gillinson 2015). It hinges on the same transformation that occurs on stage, where any given body or object is always at least two different things at once. But whereas realist theatre attempts to conceal this doubling and transformation, *An Oak Tree* actively foregrounds it.

The narrative of *An Oak Tree* centres on a grieving father (indicated in the script as simply 'Father') and the man inadvertently responsible for his daughter's death. After his young daughter Claire is knocked down and killed by a car, the Father believes that he has performed his own transformation, like the one described by Craig-Martin. According to him, his daughter has not been lost; she has been turned into an oak tree at the side of the road where she was killed. This is what the Father has come to tell the Hypnotist who was behind the wheel of the car, interrupting his disastrous stage show in an attempt to achieve some kind of closure or resolution.

This story is overlaid with the interactions of Crouch and his fellow actor, who is a different person every night. The key formal device of *An Oak Tree* is that the Father is always played by a new performer (male or female), who has no prior knowledge of the script. They arrive deliberately unprepared to the stage, where they are guided through the play by pieces of text and instructions fed to them by Crouch through an earpiece. The action of the play switches back and forth between scripted exchanges between Crouch and the second performer and the confrontation of the Father and the Hypnotist at the Hypnotist's show. Within this structure, there are also narrated flashbacks to the scene of the fatal car

accident and its aftermath. Throughout the play, part of the drama is watching the second actor blindly feel her or his way through the performance, forced to respond in the moment. We also see, very clearly, the transformations that so much theatre seeks to hide. We watch as an actor occupies a role they have never encountered before, or as a piano stool, for instance, stands in for a tree.

Described in this way, *An Oak Tree* might sound like an abstract, self-regarding reflection on the art of theatre. But while it does interrogate how theatre works, the formal strategies of the show are inextricably entwined with the narrative. The device of the unprepared actor, for instance, does not just highlight the workings of representational theatre. As they fumble their way through the play, the second performer's situation also reflects the intense bewilderment of the grief experienced by the Father. It's apt, meanwhile, that Crouch plays a hypnotist, with the role alluding to theatre's own incomplete illusions. When we watch a play, we want to be taken in by the fantasy, but at the same time we are always aware that it is just a trick, a story.

An Oak Tree, like all of Crouch's work, was born partly out of his frustration and disillusionment with mainstream theatre conventions. Crouch studied drama at the University of Bristol and after graduating he formed the theatre company Public Parts, which devised and toured its own work for a number of years. Following this, Crouch took a postgraduate acting course at Central School of Speech and Drama and then spent several years as a jobbing actor, a profession that he found increasingly dispiriting. He felt restricted by the mechanisms of the industry, the strictures of mainstream theatrical form, and the insistence upon psychological realism from actors. His first play *My Arm* (2003) was a reaction

against the limitations of realism: a monologue about a boy who raises his arm above his head and refuses to take it down, performed by Crouch with both arms resolutely at his sides. It introduced concerns – about conceptual art, theatrical authorship, representation and the role of the audience – that have persisted in Crouch's plays ever since.

In this book, I go on to address each of these concerns in turn. The first chapter uses the influence of Craig-Martin's artwork *An Oak Tree* as a starting point for considering the play within the frame of conceptual art. Crouch's plays are littered with references to the contemporary art world and often adapt ideas and models from conceptual art. Here I explore what might be gained from looking at *An Oak Tree* in the context of conceptual art, investigating the artistic genealogies that have informed the play. I then raise and tackle the question of why it is essential that *An Oak Tree* takes place in a theatre and not in an art gallery.

Chapter 2 moves on to look at Crouch's collaborative methods of theatre-making. While the text of *An Oak Tree* bears Crouch's name, he always works closely with a number of collaborators in the process of creating any piece of theatre. In this chapter I explore that process, posing the question of who can really be identified as the 'author' of *An Oak Tree*. I also examine the elements of indeterminacy built into Crouch's work in general and *An Oak Tree* in particular, asking to what extent these 'open' aspects of the plays can be said to be 'authored'.

In the third chapter, I consider how *An Oak Tree* exposes and interrogates conventions of theatrical representation. Here I look at how Crouch's work disrupts familiar stage fictions and to what ends. This chapter also explores the relationship between page and stage in *An Oak Tree* and the role

of uncertainty and ambiguity in the script. These discussions have implications not just for how we understand Crouch's theatre, but for how we think about theatrical performance in general.

Finally, Chapter 4 turns its gaze on the audience. How are we implicated in the drama? In what ways is our presence necessary? And how does our involvement alter both the theatrical event and our own engagement with it as spectators? The chapter addresses questions such as these, as well as taking into consideration the significance of emotion in the experience of watching *An Oak Tree*.

Scene 1 of *An Oak Tree*, in which the device of the second actor is being established, contains the following exchange:

FATHER: How free am I?
HYPNOTIST: Every word we speak is scripted but otherwise –
(Crouch 2015b: 21)

Early on in the show, therefore, the audience is clearly told that this is a scripted piece of theatre, yet at the same time a seed of doubt is planted in our minds as to how restrictive – or prescriptive – this scripting really is. As Crouch has explained, 'I really want you as an audience to know that every word I speak is scripted, and that's not reductive or prohibitive or restrictive in any way, I think it's quite the opposite, it's actually super freeing' (2015a).

This sounds like something of a paradox. How is it possible to be scripted yet free? But what Crouch is playfully subverting with this response is the idea that the stage is a simple vehicle for the page. *An Oak Tree* pointedly demonstrates the limits of the script, which can never fully determine all the mutable elements of performance. Live theatre exists in the space

of that mischievous 'otherwise', where possibilities multiply and things can go wrong. *An Oak Tree* is extraordinary not because it contains this truth, but because it exposes it, revealing to us what was there all along.

Conceptual art

When discussing *An Oak Tree* as a play on the page, it's crucial to note that for Crouch 'the text is not the thing. The text is a series of residues … of the thing' (2015a). In this respect, Crouch's texts – and perhaps, it might be argued, all texts – function a bit like the documentation of ephemeral conceptual artworks. We can access, for instance, Bruce McLean's 1971 performance *Pose Work for Plinths* (in which the artist struck a number of comical poses on sculpture plinths) through its photographical documentation, but this is merely a trace of the original, live work. Likewise the written play is at once a fragment – not synonymous with the live performance – and a complete object in its own right. It exists before the production (unlike a photograph), but also endures long after that production has been and gone.

This is no accidental comparison. An interest in and implicit dialogue with the art world is a persistent feature of Crouch's plays. In *My Arm*, the protagonist's motiveless act of keeping his arm in the air turns him into an object of fascination for artists, who exploit him for their own gain. *ENGLAND* (2007) was made for gallery spaces and offered,

among many other things, a critical view of the trading of artworks as commodities. The narrative of *Adler and Gibb* (2014) revolves around the fictional conceptual artists of the title, who aim to 'dematerialise' their artworks and disappear from the harsh glare of press and public. And as we saw earlier, *An Oak Tree* is inspired in part by Craig-Martin's work of the same name, which was an important and controversial contribution to the British conceptual art movement.

Both the perceptual and the conceptual are recurring reference points throughout *An Oak Tree*. When the Father describes the night of his daughter's death, for instance, there is an emphasis on the senses ('That night has a colour, a touch and a sound'), yet these are all conveyed through words alone (2015b: 42). Later in the same scene, emotions are communicated through colours ('Our pulses raced in purple … Our stomachs knotted in green … Dawn's knees gave way in white') – suggestive perhaps of the expressive qualities of visual art and the inadequacy of language in moments of extreme distress (42–43). Aesthetically, though, *An Oak Tree* has more in common with conceptual art than with its visual precursors: the stage, bare apart from eight chairs, a piano stool and a visible sound system, offers little in the way of visual stimulus, with images and ideas instead being produced in the minds of audience members, often through the use of language.

At another point in the play, Claire is described by her grieving Father as 'between lines, inside circles, hiding beneath angles' (51). Following her death, her physical existence (at least in her Father's mind) is replaced by a series of artistic representations or metamorphoses. This idea – and perhaps, by extension, some of the principles of conceptual art – is eventually attacked by the Father's wife, Dawn

(whose words are performed by the Hypnotist): 'It's like some abstract intellectual fucking concept for you, isn't it. Claire's death. She never existed for you in the first place, did she? She was just some idea' (61). Conceptually, of course, this works on multiple levels: for us, Claire *is* 'just some idea', and this speech can be interpreted as a self-aware critique of the way in which Crouch has manipulated the highly emotive idea of a dead child in order to make intellectual points – while at the same time this statement is rehearsing one such intellectual experiment. Crouch has, intriguingly, described words (arguably the principal medium in which he works) as 'the ultimate conceptual art form' (Rebellato 2015: 5). As Dan Rebellato puts it, words 'point at concepts but are also conceptual things in themselves' (*Ibid.*); we might think of them as conceptual art squared.

I'm far from the first to note the importance of conceptual art to Crouch's theatre-making. It's an influence that he himself often talks about in interviews, and it has been commented on by scholars such as Emilie Morin (2011) and Stephen Bottoms (2009). Morin in particular has been keen to emphasise Crouch's debt to conceptual art and experimental music, influences that she suggests have been largely ignored by critics. However, there remains room for a more extended discussion of conceptual art in relation to *An Oak Tree* in particular, taking into account aesthetics, context and the positioning of the spectator.

In 2014, artist and comedy writer Miriam Elia caused a stir when she released *We Go to the Gallery*, a spoof Ladybird Book claiming to help parents and young children navigate contemporary art. On one page, the mother tells her daughter that the smell of a pile of rubbish bags represents 'the stench of our decaying Western civilization' (Elia 2015: 32);

on another, the children enter an empty room and are told 'There is nothing in the room because God is dead' (12). The book playfully skewered the pretensions of the art world and irreverently captured the frustrations that many have with it. There is, as artist Grayson Perry suggested in his Reith Lectures for the BBC, 'a kind of complacent idea in the art world that anything can be art now' (2013). His lectures engaged with the thorny, age old question of 'what is art?', in the process reflecting on some of the more sceptical popular attitudes towards contemporary artworks. Surveying the modern gallery, many might well wryly say, echoing one of the characters in *My Arm*, 'art is anything you can get away with' (Crouch 2011a: 36).

Part of the challenge posed by conceptual art – and part of what Elia was poking fun at in *We Go to the Gallery* – is that it is primarily about *ideas* rather than *craft*. Conceptual art usually refers to a movement spanning the 1960s and 1970s and including artists like Joseph Beuys, Gilbert & George and Yves Klein, though conceptual artworks have continued to be created by artists into the twenty-first century. In his famous 'Paragraphs on Conceptual Art', Sol LeWitt (another of the key artists involved in the movement) defined this art as work in which 'the idea or concept is the most important aspect' (1967: 79). It is the *idea* that drives the artwork, not the skill or technique of the artist. And because it is about ideas and processes, not materials and visuals, conceptual art can take many different forms: performances, instructions, found objects, written statements (and, yes, rubbish bags and empty rooms).

Conceptual art, then, is often – if not always – about transformation. Via ideas and processes, seemingly ordinary objects become works of art. An important influence and

antecedent for the movement was Marcel Duchamp (a figure whom Crouch often refers to) and his 'readymades': everyday objects chosen, modified and put on display by the artist. Duchamp's iconic 1917 work *Fountain* rewrote the rules of what could and could not be considered art, transforming a standard, manufactured urinal into an artwork simply through the act of exhibiting it. With *An Oak Tree*, Craig-Martin similarly prodded at the limits of transformation in the context of the art gallery. He explains:

> I considered that in *An Oak Tree* I had deconstructed the work of art in such a way as to reveal its single basic and essential element, belief that is the confident faith of the artist in his capacity to speak and the willing faith of the viewer in accepting what he has to say. In other words belief underlies our whole experience of art: it accounts for why some people are artists and others are not, why some people dismiss works of art others highly praise, and why something we know to be great does not always move us.

> (2001: 20)

There are strong resonances here with theatre. Belief also underpins an audience's experience of watching a performance, which constantly asks its spectators to accept the notion of one thing standing in for another. Ordinarily, in both the gallery and the theatre, this thought process is unremarked upon. We accept art as art because it is displayed in an exhibition; we read the representations of the stage without them having to be explained to us. What Craig-Martin and Crouch do is foreground and thus trouble the transformations that occur in the gallery and in the theatre.

The influence of conceptual art on *An Oak Tree* might also be seen in its faith in 'liveness' (the quality of the live experience) and in its efforts to resist commodification. Conceptual art often attempted to challenge or bypass the commercial structures of the art establishment, producing artworks that – at least in theory – could not easily enter the market. Crouch's work, meanwhile, pushes against many of the structures of commercial and/or establishment theatre. His shows, as already observed, emerged from his frustration with theatrical realism, and he has expressed his excitement about 'theatre not being tradeable because there's no materiality to it' (2015a). It's worth noting here that the ephemerality of live performance has long been the focus of claims for the art form's inherent radical politics and resistance to capitalist commodification. The logic goes that while visual artworks are tradeable objects, performance only exists in the moment and then it disappears – or, as Peggy Phelan influentially pronounced, performance 'becomes itself through disappearance' (1993: 146). This celebrated liveness is highlighted and arguably enhanced in *An Oak Tree*, which is significantly different every night thanks to the unpredictable and unrepeated presence of each new guest performer.

But the inexorable commodification of all types of art – whether visual or conceptual – should give us pause here. The material traces left behind by conceptual artists in the 1960s and 1970s have, as Bottoms notes, accrued considerable financial value over the years (2009: 75), and these artists have been absorbed by the very establishment they sought to shun. The British conceptual art movement, for example, was the subject of a major exhibition at Tate Britain in 2016, while artworks by Beuys and LeWitt have sold for hundreds of thousands of dollars. Cristina Delgado-García has even suggested that for

the artists themselves the intent to sidestep commodification was 'never completely sincere' and served a largely mythical purpose (2014: 79). Meanwhile claims for live performance's resistance to commodification are difficult to sustain. Today we live, as many have noted, in an 'experience economy'. In a world of increasing global reproduction and simulation, the one-off live event is a sought-after experience and one that can be sold at a premium. Just look at the immersive performances of a theatre company like Punchdrunk, who construct their events in a way that encourages repeat viewings and offer pricey VIP packages on the basis of unique, one-on-one live encounters that are not available to regular audiences. *An Oak Tree*'s device of the second actor does not escape similar possibilities for commercial exploitation: its form invites marketing cries of 'different every night!', while during its run in New York it attracted interest through guest appearances from stars like Mike Myers and Frances McDormand. An unpredictable and unique evening's theatre – and especially one in which you might just see a celebrity – is clearly a big selling point.

Alongside its interest in transformation and its attempts (whether successful or not) to resist commodification, another feature that *An Oak Tree* shares with conceptual art is its interest in the spectator. A crucial shift within the art world over the last century or so has been the increasing involvement and acknowledgement of the observer in the embodied act of viewing. In the eighteenth and nineteenth centuries, as Brian O'Doherty traces in *Inside the White Cube* (1999), it was the frame that enclosed and defined the artwork, which guided the viewer's eye through the use of perspective. With the invention of photography, though, the window of the frame was challenged and the viewer became increasingly aware of

both the blank space either side of the picture and her individual relation to the artwork in the space of the gallery – an awareness that also inflected pictorial art. From Impressionism onwards, therefore, the spectator became implicated in the *experience* of the artwork. In the twentieth century, art accordingly adopted (often self-critical) attitudes towards the gallery and the spectator. Context, O'Doherty argues, became content. This can be seen in conceptual artworks such as Roelof Louw's *Soul City (Pyramid of Oranges)* (1967), which invited gallery visitors to take an orange from the (ever-decreasing) pile that made up the exhibit, or Ian Burn's *Mirror Piece* (1967), which used a simple mirror mounted on the gallery wall to provoke viewers into seeing themselves and their surroundings differently.

There has, however, been resistance to the involvement of the spectator and what some have referred to as the increasing 'theatricality' of art. In the 1960s, prominent art critics like Clement Greenberg and Michael Fried objected to the increasing number of artworks that were in dialogue with their surroundings and with the gallery visitors viewing them. Greenberg and Fried believed firmly in the ideal of artistic autonomy: the notion that works of art are self-contained. The autonomy of the artwork is of course disrupted by the presence of the viewer; if an artwork requires a spectator (as theatre requires an audience) then it can no longer stand alone. In his 1967 essay 'Art and Objecthood', Fried attacked art that 'is concerned with the *actual circumstances* in which the beholder encounters [it]' (1998: 153, my emphasis). The spectator who, in Fried's words, 'knows himself [*sic*] to stand in an indeterminate, open-ended – and unexacting – relation *as subject* to the impassive object on the wall or floor' (155: original emphasis) increasingly becomes a viewer who is drawn

into an encounter with the work of art and is prompted to acknowledge their presence alongside it. This 'theatricality', in Fried's opinion, is 'the negation of art' (153).

As Rebellato notes, Fried's objections were largely ignored, and in some instances his arguments suggested to artists that theatricality was an area that was ripe for experimentation (2013a: 24). This then led to the growth of live art, another form that has influenced Crouch's work. It is possible to discern two main genealogies for live art: theatre and fine art. Beth Hoffman explains that live artists and scholars have generally favoured the latter (2009: 100), a lineage that has been emphasised in influential histories such as Roselee Goldberg's *Performance Art: From Futurism to the Present* (1988). As the title of Goldberg's book suggests, live art and performance art are often spoken of in the same breath and are sometimes even used interchangeably. Live art, though, gained currency as a term in the UK in the 1980s, and while the work it described shared features with earlier performance art (including the performances of conceptual artists), the phrase 'live art' usually refers to the practices that emerged in this period and after.

Live art is, according to Hoffman, a practice that emerges from 'a principle of non-identity, the lack of a definition outside the negation, subversion or transgression of a received practice or set of practices' (2009: 101–102) – a genre that has, in other words, defined itself in *opposition* to both fine art and theatre. This antagonistic position is also stressed by the Live Art Development Agency (LADA), which notes the twin influences on live art of the 'rejection of objects and markets' by twentieth-century performance artists and of practitioners who 'broke the traditions of the circumstance and expectations of theatre' (2016).

In recent years, meanwhile, the model of relational aesthetics – outlined by curator Nicolas Bourriaud in a book of the same name – has been particularly influential in discussing a strand of contemporary art that seems more interested in the interaction between artwork and spectators than in the materiality of the artwork itself. Bourriaud defines relational aesthetics (which he explicitly differentiates from conceptual art, though these artistic movements share a concern with the spectator) as artistic practices that take the social encounter as their subject *and* their material (2002). Among the artists who he considers to exemplify this trend are Liam Gillick, whose work includes the construction of discussion spaces, and Rirkrit Tiravanija, the creator of installations that invite participants to share activities like eating or playing music. In an age in which capitalism and digital communications are increasingly atomising and marketising the social realm, Bourriaud argues that this kind of art is inherently political because it carves out a space for real actions and interactions.

While in Bourriaud's terms the encounters between strangers that are generated by relational artworks have an essentially utopian character, this view has been criticised. The most famous riposte to Bourriaud comes from Claire Bishop, who has challenged his simple equation of relationality with utopian social possibilities (2004). What we should really be assessing, she proposes, is the *quality* of the interactions in question. In contrast to relational aesthetics, Bishop puts forward the model of 'relational antagonism'. Relational antagonism 'would be predicated not on social harmony' – which, she argues, is often created at the expense of difference and dissensus – 'but on exposing that which is repressed in sustaining the semblance of this harmony' (2004: 79).

Both Bourriaud and Bishop, whose critical work has often been applied by scholars to theatre and performance, offer useful (if conflicting) frameworks for thinking about *An Oak Tree*. First, there are clear links to be drawn between Bourriaud's relational aesthetics and the utopian claims sometimes made for performance. Many theatre-makers similarly stress the political potential of drawing the audience into live, collective encounters – something that *An Oak Tree* arguably achieves by emphasising the co-presence of its spectators right from the start. More specifically, the idea of 'an art form where the substrate is formed by inter-subjectivity, and which takes being-together as a central theme' (Bourriaud 2002: 15) certainly speaks to *An Oak Tree*, as does Bourriaud's description of the artwork as 'an ensemble of units to be re-activated by the beholder-manipulator' (20). Here, as in *An Oak Tree*, the emphasis is on viewers' interpretations rather than on the governing intention of the artist. Bishop, meanwhile, applies helpful caution and modification to Bourriaud's model. In Crouch's shows, the *quality* of an audience's engagement is important (as he and his collaborators have frequently stressed), while his plays attempt to hold open space for disagreement and dialogue, as well as outright antagonism. I'll discuss this again when I turn my attention to the audience in Chapter 4.

Surveying Bourriaud's and Bishop's opposing perspectives, Duška Radosavljević brings them together by suggesting that what they share is a concern with a new form of authorship, which sits somewhere between visual art and theatre (2013). Other critics, including Shannon Jackson in her book *Social Works* (2011), have also observed the closeness and dialogue between visual art and theatre practices in the twenty-first century. More and more, the gallery seems to be borrowing

from the theatre, while theatre-makers are increasingly influ-
enced by artists. Crouch's work sits neatly within this overlap,
combining conceptual approaches derived from the art world
(as I've shown throughout this chapter so far) with concerns
that are decidedly theatrical.

Shows like *An Oak Tree* also demonstrate the growing
proximity of theatre and live art. While live art has frequently
emphasised the ways in which it has broken away from
theatre, Hoffman persuasively argues that the two genres
are in fact closely intertwined, and that it might be more
productive to talk about the expansion of traditional theat-
rical forms (2009: 97–98). I'd argue that Crouch is one of
the few artists who have explicitly attempted this expansion,
stretching rather than breaking the boundaries of theatri-
cal practice. 'Let's expand our definitions of what a play is',
he suggests (Crouch quoted in Ilter 2011: 402), insistently
describing his shows as *plays* rather than performance pieces.
He boldly signals a new development in playwriting, mean-
while, when he notes that *An Oak Tree* is 'a different kind of
"play"' (2015b: 17). Although the scare quotes suggest some
discomfort with the idea of plays as traditionally understood,
the choice to pursue this vocabulary rather than adopt a new
one indicates an intervention in playwriting rather than an
abandonment of it.

Therefore, despite the value of thinking about *An Oak Tree*
in relation to conceptual art, theatre remains an important
point of reference for Crouch's play. Indeed, theatre lingers
in the background throughout the above narrative of artistic
developments. As Delgado-García has noted, the conceptual
artists who have exerted an intellectual and aesthetic influ-
ence on Crouch were themselves influenced by the theatrical
avant-garde (2014: 74–75). It's perhaps best, then, to think

of theatre and conceptual art as interwoven artistic genealogies. With this in mind, it's worth briefly noting some of the many theatrical precedents for Crouch's rejection of naturalistic representation. We might consider Bertolt Brecht's efforts to break down the fourth wall as a way of provoking critical interrogation, or Antonin Artaud's call for a 'total theatre' that would erase many of the distinctions between stage and audience, as well as the countless practitioners who have been influenced by them in the twentieth and twenty-first centuries. Crouch's work therefore fits into a post-Brechtian theatrical trajectory as much as a post-Duchampian artistic one.

Context, again, is crucial. Gareth White argues that, while distinctions between theatre and art are being increasingly blurred, it's still important to consider how different pieces of work choose to frame themselves. He reasons that

> what happens in a theatre building, is marketed as theatre or created by a theatre company, rather than presented or promoted by a gallery and created by an 'artist', is recognised and treated differently, though the performance activity itself might be the same in all other regards.
>
> (2013: 2)

This is largely due to expectations and conventions, which differ between art forms and genres and which have the power to determine how actions are read within their context. Something that may be old hat for a live art audience, for example, could be considered shocking and radical if staged in a mainstream theatre. It is thus crucial that *An Oak Tree* is created for a theatre rather than a gallery context (although Crouch did later experiment with staging a show in a gallery when he was commissioned to write

ENGLAND for the Fruitmarket Gallery in Edinburgh). Indeed, much of what *An Oak Tree* is doing has to be read within the conventions of theatre, on which it is implicitly commenting throughout. The play might have many affinities with conceptual art, but its real subject is theatrical representation.

Noting Crouch's emphasis on audience response, Seda Ilter suggests that the position of the spectator in his plays is much like that of the individual viewer interpreting a work of art in the gallery (2011: 395). This comparison is useful for thinking about the relationship between *An Oak Tree* and the conceptual artworks from which it took inspiration. In Crouch's work, attention is drawn to the relation between stage and audience member, with spectators asked both to interpret what is placed before them and to reflect on their own acts of interpretation. However, Ilter's argument makes a problematic assumption about the essential passivity of audience members: she sees spectators at the theatre as inactive receivers of information, whereas individuals in front of an artwork are cast in the role of interrogative thinkers. This is typical of scholarly attitudes towards theatre audiences, as we will see in Chapter 4. Ilter's view of the audience in Crouch's work also disavows the collective live experience of the theatrical event, which I'd contend is integral to any understanding of *An Oak Tree*. While it's important not to overstate and romanticise the community-building qualities of theatre, which can just as easily be an alienating experience for individual audience members, at the same time we cannot simply disregard the fact that Crouch's shows are seen in the presence of others. It matters that *An Oak Tree* is experienced in a theatre among other spectators and not in a gallery where it can be contemplated in a viewer's own time and in relative solitude.

Having opened the Reith Lectures with the massive question of 'what is art?', Perry concluded that the boundaries of contemporary art 'are not formed by what art can be, but where, who or why' (2013). Art becomes art, in other words, when people or places make it so. So great is the power of the gallery, according to O'Doherty, that it can define the parameters of what we consider art: 'things become art in a space where powerful ideas about art focus on them' (1999: 14). But while the art world may have largely accepted that framing and context, as well as the object itself, can determine what is considered an artwork, there remain squabbles about what 'counts' as theatre. Although it is possible to argue, as Bottoms does, that the theatre has 'transformational possibilities exceeding those of the gallery' (2009: 65), those transformational capacities often remain unacknowledged. As David Lane notes, Crouch's 'rearrangement of priorities regarding creation, definition, ownership, value and meaning is something theatre in the mainstream – particularly writer-led theatre – is yet to embrace fully' (2010: 130). This reluctance can be demonstrated by drama publisher Faber & Faber's refusal to publish *An Oak Tree* because, in their opinion, it was not a play. Such resistance reveals why plays like *An Oak Tree* are so important and influential. By combining ideas from conceptual art with the representational logic of theatre, Crouch points both to new possibilities in theatrical form and to the old stage conventions to which we are so often willingly blind.

Collaboration and authorship

In the notes to the second actor who will be performing in *An Oak Tree*, Crouch decisively identifies himself as 'the author' of this play (2015b: 17). This, however, is not the full story. All of Crouch's work from *An Oak Tree* onwards has been made in collaboration with co-directors Andy Smith (known professionally as a smith) and Karl James, as well as with the different performers involved on each project. In interviews about his work, Crouch is eager to highlight the importance of these collaborators, deflecting authority away from himself as the writer. 'I'm on a mission to make people aware that I'm not a solo artist,' he told *The Scotsman*, for example (Mansfield 2010). Crouch's collaborators themselves are equally insistent upon the collective nature of the works; Smith, for instance, states that 'although we are different, our status is equal' (2011: 410).

In a very palpable sense, Smith in particular was central to the conception of *An Oak Tree*. Crouch had, by his own account, come up with the narrative of the play independently, but he still needed to settle on a form. He explains that he 'wanted the father in that story not to be played by

an actor ... but to take an object and for the transformation to happen to it rather than it transforming' (Crouch quoted in Radosavljević 2013: 220). This extends a device used in *My Arm*, in which items were requested from the audience at the start of each performance to stand in for various characters in the story. Initially, in exploring this idea of a non-actor playing the Father, Crouch approached Smith with the suggestion of taking on the role. Smith firmly identifies as a theatre-maker rather than an actor; his performances usually involve him sitting down and reading from a script in front of him, with no concessions towards theatrical realism, hence Crouch's idea of casting him. He turned down the offer, but instead helped Crouch to come up with the idea of a different actor playing the Father in each performance. Crouch has described this suggestion as a 'liberating constriction' which allowed him to then write the play very quickly: 'If you have a good restriction, it is really easy: I have to make a play that will contain an actor who doesn't know the play, and suddenly ideas start flooding about devices and models of imparting character' (Crouch quoted in Radosavljević 2013: 220). Smith also played the part of the second actor/Father during the rehearsals of *An Oak Tree*, taking on a vital role in the development of the piece.

There is, however, a tension at play in Crouch's description of his work and his relationship with collaborators. He frequently stresses the role of other practitioners in the creation of his work, particularly Smith and James, yet his texts always bear his name and his name alone. And while he has said of his shows 'I wouldn't want anyone to come in going "I'm going to see a Tim Crouch show"' (Crouch quoted in Love 2014: 25), this seems slightly disingenuous to me. It is ultimately his name, rather than Smith's or James's, that lends

cultural capital to productions of his work, published copies of his scripts, and even the book you hold in your hands.

Interestingly, despite the many other ways in which he has attempted to challenge received theatrical conventions, Crouch also remains wedded to the idea of the solo-authored text. 'I still am excited by singular voices', he has said. 'I like to think that ideas can coalesce in one person more purely in a way than they can if they are negotiated amongst a group of people' (2015a). He describes his choice to identify as a writer as a result of 'not wanting to dodge responsibility' for what he puts on stage, yet he also admits that his education 'was to study writers and literature ... so I can't disentangle myself from that' (*Ibid.*). The UK theatrical mainstream (and the dramatic canon taught in schools) still largely subscribes to a focus on the individual writer as the author or primary artist behind a play, despite numerous challenges to this orthodoxy. For all Crouch's interest in collaboration and his desire to extend the boundaries of British theatre-making, this cultural focus on the playwright continues to affect his thinking and approach.

Britain's – and particularly England's – emphasis on the playwright and the playtext has also influenced responses to Crouch's work. As Morin observes, the critical discourse surrounding the work of experimental playwrights including Crouch still 'takes presumed authorial intentionality as its main mode of validation' (2011: 83). What I want to propose is an alternative approach which, while not entirely disavowing authorial intention, also acknowledges the importance of openness and ambiguity in texts such as *An Oak Tree*.

A significant point of reference here is the Fluxus movement, and in particular its event scores. Founded in 1960 by George Maciunas, the Fluxus network of artists and

composers had strong links with conceptual art and similarly challenged accepted artistic conventions. Event scores (one of the art forms most commonly associated with Fluxus) consist of short scripts of actions which often reframe the everyday as performance. The prescribed actions are typically short and/or simple, while at the same time offering multiple interpretations. Take George Brecht's 1963 piece *Danger Music Number Twenty-Nine*, which consists of the words 'Get a job for its own sake', or Alison Knowles's famous instruction 'Make a salad'. Others, like the scores in Yoko Ono's 1964 book *Grapefruit* or Bruce Nauman's proposal pieces – which Crouch acknowledges as an 'aesthetic precedent' for *An Oak Tree* (2013: 240) – operate on a purely conceptual level, issuing instructions that are often difficult if not impossible to enact. Ono's 'Cloud Piece', for instance, reads: 'Imagine the clouds dripping. / Dig a hole in your garden to / put them in.'

Crucially, Morin notes that in these scores 'Textual notation does not circumscribe the realization of the event within given parameters' (2011: 78). There are two contrasting implications of this reading of Fluxus projects. The first is that these scores have inbuilt indeterminacy – they do not 'circumscribe' their enactment. Or, to put it another way, the scores don't stipulate all the details of their performance. Knowles, for instance, doesn't tell us what to put in our salad. This indeterminacy, however, relies upon the 'given parameters' within which the event can take place, thus requiring a certain amount of determination. We're still making a salad, whether we put tomatoes in it or not.

This delicate balance between determination and indeterminacy is central to understanding Crouch's authorship of *An Oak Tree*. Often, Crouch's work – like the event scores created by Fluxus artists – has been seen by critics as containing a

certain level of indeterminacy. Aspects of his shows are left undecided in the scripts, requiring the intervention of unpredictable elements in the live performance, as well as the active involvement and interpretation of audiences. The same might be said of any play, whose textual component (no matter how detailed) cannot fully determine its performance; as Rebellato puts it, 'Language underdetermines the world' (2013a: 25). The script of *An Oak Tree*, however, consciously and self-critically foregrounds this under-determination, building in devices (such as the second actor) that illustrate the scripted-yet-unscripted nature of any individual live performance. The play shares this feature with its artistic namesake. Craig-Martin's artwork builds undecidability into its structure, underlining the supposedly transformative work of the artist while ultimately leaving interpretation (is it a glass of water? is it an oak tree?) up to the viewer.

In her book *Social Works*, Jackson discusses what she defines as 'social practices', a term that 'combines aesthetics and politics' and describes 'art events that are inter-relational, embodied, and durational' (2011: 12). Referring to Bishop's demand for relational antagonism, Jackson suggests that these social practices (within which we could include *An Oak Tree*) 'might in fact provoke their most intriguing experiences of antagonism in their recognition that ... an author "cannot be" an author' (55). In other words, authorship as we generally understand it is rendered impossible by artworks that rely – in one way or another – on the interaction of audiences for their completion or meaning. This chimes with Crouch's practice. It does not mean, however, that Crouch is simply relinquishing control over the theatrical event. As I've already suggested, indeterminacy and determinacy are two sides of the same coin;

the very fact that we as readers of the script of *An Oak Tree* can identify gaps relies upon solidity elsewhere. Crouch has explained that in his work he tries to 'generate a sense of incompleteness to some degree' (2015a). Thus, while the work may be incomplete, this incompleteness is carefully constructed.

According to Crouch, he began writing plays 'not to highlight his *authorial* presence as a writer, or even to provide himself with vehicles in which to give *authoritative* performances, but because he wanted to explore ways to *authorize* the spectator's participation in the performance process' (Bottoms 2009: 67, original emphasis). However genuine this desire, though, it raises questions. One, which I will address further in Chapter 4, is what it really means to authorise audiences. How can audiences – collective bodies made up of diverse, autonomous individuals – be engaged and granted agency? Another question to ask is: how far does Crouch really relinquish authority?

'Don't you think it's a bit contrived?' asks the Hypnotist in Scene 7 of *An Oak Tree*, commenting on the script (2015b: 65). This is a playful nod towards potential criticisms of the play, archly acknowledging its narrative and formal mechanisms of control. One of Crouch's fears during the making of *An Oak Tree* was that 'we will try and control everything', a possibility that he was keen to guard against (2013: 242). The second actor, as well as serving many other formal purposes within the piece, can be seen as a tool designed to take some of the control away from Crouch, while at the same time this device underlines his manipulation of the onstage action. We see Crouch guiding and issuing instructions to his fellow performer – his role as 'author' is made legible to an audience – yet we are also made aware that this could all fall apart at any

moment thanks to the second actor's lack of knowledge and preparation. Crouch has, nonetheless, been accused of

> 'control freakery', because of the extent to which the 'logic' of representation 'governs' the performance: the second actor is allowed no opportunity to improvise spontaneous responses to the situation, and is instead 'enslaved' by the text to the extent that even the 'off-script' exchanges with Crouch are pre-scripted.
>
> (Bottoms 2009: 70)

The play, however, attempts to challenge this sense of enslavement. Crouch stresses to the second actor in his notes that 'Everything you say in the play (and everything I say in the play) has been carefully scripted', yet he insists, nevertheless, that 'the play IS improvised, it's just not improvised with words!' (2015b: 17). The language may be fixed, but everything else is up for grabs.

At this point, it's worth turning again to Morin. She uses Crouch's work (and specifically his later play *ENGLAND*) as an example of 'forms of theatre which rely upon indeterminacy as practice, rather than the primacy of plot and character' (2011: 74). As well as acknowledging the influence of contemporary art and the Fluxus movement, she draws at length on John Cage's 1958 lecture on indeterminacy, noting how indeterminacy is contingent on control. Throughout his lecture, Cage's examples illustrate how 'composition which is indeterminate with respect to its performance' depends upon certain aspects being determined while others remain unfixed, making the role of the performer 'comparable to that of someone filling in colour where outlines are given' (1961: 35). Morin's analysis also stresses the serious and

committed intentions behind practices of indeterminacy, which are far from mere playful duets with chance.

Extending Morin's discussion, meanwhile, Jack Belloli has focused on the controlled conditions that allow for indeterminacy to arise. He discusses the interplay of determinacy and indeterminacy in Crouch's work with reference to two different models of craft. First, he cites Richard Sennett's notion of 'material consciousness', which stresses a balance 'between determining the shape of material and allowing it to remain indeterminate' (2016: 14); put simply, this implies the exertion of limited control on the part of the playwright. Second, Belloli turns to Tim Ingold's definition of skill as the craftsman's involvement in a 'taskscape' (17), which suggests the dispersal of control among numerous collaborators, including the audience. In the first model, agency is divided between Crouch and his audience, whereas in the second this agency does not reside with either, but both instead are seen as participating in a wider *system* of creation and interpretation. According to Belloli, Crouch's earlier work can be seen as representative of the former model, while his later play *The Author* (2009) moves towards the latter. Ultimately, Belloli understands Crouch's work as an example of 'fully distributed agency' (24). He also argues that this distribution of agency 'trains' audiences for the world beyond the theatre, though I think this claim somewhat overstates the practical political potential of the shows.

Morin's article is useful for establishing some of Crouch's artistic precursors and for beginning to explore the fixed outlines within which indeterminacy can emerge. In *An Oak Tree*, though, it would be more accurate to say that indeterminacy, rather than replacing plot and character in the hierarchy

of performance as Morin claims, is closely intertwined with the narrative of the play. The unpredictability brought about by the presence of the second actor is much like the unpredictability of grief, while the possibility of the performer appearing lost as they navigate the previously unseen script might mirror the disorientation of bereavement. Belloli puts an increased and persuasive emphasis on the dispersed craft and control that create seemingly indeterminate theatrical situations, though his argument that Crouch's theatre is one of 'fully distributed agency' seems at odds with the prominence his discussion gives to Crouch as the writer – if not the ultimate author – of the plays.

In Crouch's work, then, there is a simultaneous movement of relinquishing certain aspects of control and underlining others. He is not entirely unique in this respect. As opposed to plays concerned with constructing fictions and concealing the guiding hand of the playwright, there was a strain of new playwriting in the 1990s and 2000s that disavowed fiction and retreated from authorial commentary. Rebellato has written about this trend, citing Crouch alongside playwrights like Martin Crimp, Sarah Kane and Simon Stephens. He argues that 'These tactical withdrawals from authorship in fact reassert and underline authorship; it is actually the mainstream tradition of new writing with its creation of coherent and transparent fictional worlds that keeps the author invisible' (2013a: 25). The making visible of the playwright and his box of tricks is something that Crouch has explicitly drawn attention to in his work, saying 'I think *An Oak Tree* goes to the heart of those patterns [of subterfuge and deceit in all theatre] by putting them up front, by being completely open about them' (Crouch quoted in Bottoms 2009: 70).

In *An Oak Tree* this is achieved, for example, by explaining the role of the second performer from the very beginning and by clearly showing pages of the script to the audience. Writerly manipulation may still be present, but it is exposed rather than discreetly tucked away.

Quoting Crouch, Rebellato suggests that 'By refusing to assert his authority over the performance "it becomes a community of ownership"' (2013b: 130). There might, however, be a kind of authority involved in this very disavowal of authority. Fellow theatre-maker Chris Goode (who has himself worked with Crouch on his later show *The Author*), makes an intriguing claim that 'what is authored is not the event, but the space in which the event takes place' (2015: 84). This, he adds, 'does not amount to a dilution or a dissipation of the will of the author, but an enlargement of it' (*Ibid.*). Therefore it can be argued that when Crouch relaxes his authorial control, handing over a certain amount of responsibility to audiences or to the unrehearsed second actor, 'authority is not weakened but extended' (*Ibid.*). Crouch may not be able to (and clearly he does not want to) control everything within any specific performance of *An Oak Tree*, which as an event offers potentially endless permutations. Still, though, these uncontrolled and uncontrollable elements of the show are only made possible inside the *space* Crouch has authored, whose outlines he and his collaborators have delineated.

There is a further tension between the apparent openness and indeterminacy of Crouch's scripts and the fact that they are written primarily for Crouch (alongside others) to direct and perform in. He has explained that for him 'there is little distinction between script and production. The text to *An Oak Tree* is only a blueprint for its production. Written into my plays are … how I think they should be performed'

(Vile 2015). While he does not rule out other productions of his plays – and, indeed, other theatre companies around the world have mounted performances with which Crouch has had little to no involvement – he is first and foremost writing words with a specific performance in mind, rather than creating a script that will go on to be interpreted and staged by other theatre-makers. 'I never wrote [the plays] thinking about other people doing them', Crouch has explicitly said (2015a). He also says of his writing process: 'I write with an idea of what the physical stage might mean – in addition to the words. I write with, perhaps, a stronger idea of form than some writers – an idea that form is also content' (Vile 2015). Therefore the plays are, in a sense, only open to the extent that Crouch wants to create openings for himself and his collaborators in performance.

I think that we can begin to resolve some of the above contradictions by considering Crouch as a 'procedural author', a term that I'm borrowing from Gareth White. The concept originally comes from Jan Murray, who coined it to describe the role of computer game designers. The key point is that procedural authorship involves 'writing the *rules* by which the texts appear as well as writing the texts themselves' (Murray quoted in White 2013: 31, my emphasis). White's application of this to theatre is productive: he uses it to indicate how authorship can be passed back and forth between theatre-maker and audience member (2013: 31). While White is applying this model to theatre that is participatory and interactive in a way that Crouch's work is generally not (although audiences are certainly involved in his shows), the idea of the 'procedural author' is still relevant to *An Oak Tree*. This model of authorship is flexible enough to account both for the authorial control retained by Crouch,

whose intentions undoubtedly shape *An Oak Tree*, and for the dispersal of authorship among collaborators and audience. As well as a generator of narrative, Crouch as a writer is crucially a generator of *rules*. How those rules are interpreted, though, can only be discovered in the process of playing the game.

Representation

'The joy of *An Oak Tree*,' according to Rebellato, 'is that it explains away how all theatre works, but then does it anyway' (2015: 8). It shows us the mechanics of theatrical magic – how one thing stands in for another, how transformations occur, how we as an audience collectively suspend our disbelief – while it proceeds to put those mechanics in motion. There is, in one sense, nothing extraordinary about *An Oak Tree*. Indeed, Crouch insists on the simplicity of his work: 'I am just playing with that space between what we say something is and what it actually is, which happens in theatre *all* the time' (Crouch quoted in Ilter 2011: 400, original emphasis). Even in the most realistic of plays, that gap between what things are and what the performance tells us they are always exists.

And it's not just in theatre that we find this space. In the opening scene of *An Oak Tree*, there's a reminder that the magic of the stage is something inherent to human existence – as natural as play. As the rules of the piece are being established, there's an echo of children's make-believe in the question 'What are you being?' (2015b: 21). Children don't

need realistic props or costumes in order to transform into something else; they just say what they're being and they become that thing. Or, in Crouch's words, theatre is a 'game that is so effortlessly played by young children who need no figurative support to make their play real' (2014). This is the representational logic of *An Oak Tree*. Crouch says he's a hypnotist, so he is. The Father says his daughter has transformed into an oak tree, and so she has.

'You will see no false nothing false tonight,' the Hypnotist falteringly promises at the start of his act (2015b: 25). Moments later, he adds that 'anything could happen' (26). These assertions, like so much else in *An Oak Tree*, are invested with double meaning. On the face of it, this is just the clichéd patter of the showman. However, such lines are also suggestive of the theatrical situation that they inhabit. The two promises, in this context, are both true and not true. Crouch does not show us anything false; he strips back illusion, exposing all the cogs. The wizard is revealed to be just a man pulling levers. Yet theatrical transformations unfold nonetheless, compelling us to invest our emotions in this patently fictional narrative. The proclamation that 'anything could happen', meanwhile, is one that is often attached to the live event. The unpredictability of liveness – the promise that no two nights will ever be quite the same – is at the heart of its appeal. As we have already seen, though, such uncertainty can only occur within certain fixed horizons.

In his notes for *An Oak Tree*, Crouch quotes actor and mime artist Étienne Decroux: 'For art to be, the idea of one thing must be given by another thing' (Crouch 2013: 232). He goes on to ask whether this 'idea of one thing being given by another' might be 'the North Star for the whole oak tree experience' (*Ibid.*). This concept is indeed a central

and guiding principle for the play. One thing standing in for another – in other words, representation – is right at the heart of *An Oak Tree*. The play takes this basic feature of all theatre and makes it the central subject of the dramatic action. An unprepared actor stands in for a grieving father. An oak tree by the side of the road stands in for a lost daughter. Everything refers to something else.

Crouch also blurs the line between representation (one thing standing in for another) and transubstantiation (one thing actually becoming another). The idea of transubstantiation derives from the Catholic Church, which teaches that during Mass the substance of the Eucharistic offering, wine and bread, is transformed into the blood and body of Christ. The wine and bread – while their outward appearance remains the same – do not simply *stand in* for the blood and body of Christ; they *are* the blood and body of Christ. This is the idea that Craig-Martin appropriates when he insists of his artwork: 'No. It's not a symbol. I've changed the physical substance of the glass of water into that of an oak tree,' adding 'I didn't change its appearance. But it's not a glass of water. It's an oak tree' (Craig-Martin 1973).

Transubstantiation is again consciously echoed by Crouch in *An Oak Tree* when the Father says 'I scooped up the properties of Claire and changed the physical substance of the tree into that of my daughter' (2015b: 52). This is followed later by a series of insistences similar to Craig-Martin's:

HYPNOTIST: Say, 'It's not a tree anymore.'
FATHER: It's not a tree anymore.
HYPNOTIST: Say, 'You're not looking.'
FATHER: You're not looking.

HYPNOTIST: Say, 'I've changed it into Claire.'
FATHER: I've changed it into Claire.

(Crouch 2015b: 64)

At the same time, while the play worries away at the distinction between representation and transubstantiation, Crouch is also aware of the fact that everything he puts on stage is automatically caught within the representational machinery of the theatre. *An Oak Tree* may experiment with the idea of one thing 'really' becoming another, but the 'real' itself is a troubled category in a theatrical context. As Bottoms argues, 'Placed within the frame of art, the "real" is always already representational' (2009: 74). Whenever we see something on stage, it inevitably enters a representational relationship.

There are numerous examples in *An Oak Tree* of these hazy boundaries between 'reality', representation and transubstantiation. Throughout the Hypnotist's act, doubling and representation are constantly and playfully referred to. 'They know this isn't a piano,' says the Hypnotist, to take just one example (2015b: 37). Among all the other stand-ins, the Father eventually becomes a representation of the Hypnotist's guilt:

> And then – And then, when I click my fingers, you'll become convinced you've done something terrible, and you'll feel really guilty – truly terrible, ladies and gentlemen. When I click my fingers, you'll be convinced that you've killed someone. Yeah. You've killed a little girl, a girl, haven't you, and you'll feel really awful. A little girl. Nod your head if you understand.
>
> (39)

As the trick continues, the Father becomes an outlet for the Hypnotist's own feelings of shame and culpability; he is

a stand-in self on which the Hypnotist can heap his own suppressed feelings. 'How does that make you feel?' asks the Hypnotist. 'What do you wish you were? I bet you wish you were dead!' (*Ibid.*). The Father then obediently repeats the words 'I wish I were dead' over and over, pushing both the Hypnotist and the illusion to breaking point, until eventually he is snapped out of the act with the word 'SLEEP' (40). The representation, as an inadequate (and painfully ironic) proxy for the Hypnotist's deep and destructive feelings of guilt, falls apart.

In the penultimate scene, meanwhile, one speech in particular foregrounds the strange doubleness (or sometimes even tripleness) of the theatrical situation. Claire's mother Dawn – her speech reported and performed secondhand by the Hypnotist – says: 'That is a tree, I am your wife, this is your daughter, that is a road. This is what matters. This' (65). Her words convey the 'truth' within the narrative, attempting to make the Father face facts, but at the same time they are patently *untrue* in the space of the theatre. Here, the tree is a piano stool, the wife is the Hypnotist (played by Crouch), the daughter is a chair, the road is the stage. For Crouch, this kind of doubleness and ambiguity is generative rather than problematic: 'Contradiction is not a bad thing for me in theatre, if anything it is a fundamental thing in theatre that I should not be the thing that I say I am' (Crouch 2015a). What such contradiction creates is an opening for different audience interpretations of the competing 'truths' on offer. Bottoms's 'hunch', for instance, is that the different levels of narrative and representation at play in moments like this are 'somehow perceived simultaneously, superimposed on one another' (2009: 71). Audiences, in this model, are able to see all at once the piano stool, the oak tree and Claire, with each of those individual layers of representation impacting upon one another.

When considering these kinds of multiple layers, it's helpful to think about Crouch's approach to theatrical representation in terms of metaphor. Metaphor is, after all – to once again echo Decroux – the idea of one thing being given by another thing. In contrast to models of theatre spectatorship built on the idea of illusion, Rebellato compellingly argues that we should think of theatrical representation as metaphorical (2009). Metaphor, significantly, does not dictate the connection between the things it compares and does not rely on resemblance in order to make sense. There is nothing, therefore, to stop a piano stool from being a metaphor for an oak tree (or a daughter). Indeed, Crouch believes that 'If we work too hard to make everything look like the thing we say it is, then we're also removing any sense of the game of art' (2014). Another benefit of applying the logic of metaphor to theatrical representation is that it allows for the stand-in (the piano stool, in this instance) to hold meaning and significance. We don't use metaphors to simply refer to something; we use metaphors to make a comparison that in some way enhances – or perhaps complicates – understanding of the thing we are referring to. Or, as Rebellato puts it, we are 'equally as interested in the metaphor as the object it represents' (2009: 26). This is, I think, especially true of the second actor in *An Oak Tree*, whose role in the piece is as interesting in its own right as the character they are representing.

Particularly when applying Rebellato's theory to *An Oak Tree*, though, I think it's important to hold on to some of the things that his explanation of theatre as metaphor jettisons. Rebellato argues, for instance, that descriptions of theatrical representation as illusionistic are inaccurate because when we experience illusions we have '*mistaken beliefs* about what we are seeing' (2009: 18, original emphasis). But I'm not sure this

statement always holds. While the word 'illusion' carries associations of deception, it is possible to appreciate a deception without being entirely taken in by it. The enjoyment of the magician's illusion, for example, is predicated at least partly on the knowledge that a trick is being played on us, even if we're not quite sure how. As I've already suggested, the magician's (or hypnotist's) trick is an apt analogy for theatre, in which appreciation derives both from the stage fiction and the manner of that fiction's construction. While experiencing any piece of theatre, meanwhile, I would suggest that we often have an inconsistent relationship with the illusions on stage, oscillating in and out of absorption in the fictional world. Even in *An Oak Tree*, which makes such efforts to reveal its trickery, there are moments when it's possible to be swept away by the narrative.

I also think there's more to take from Kendall Walton's theoretical model of theatrical performance as make-believe than Rebellato allows. The questions Rebellato puts to Walton about our interaction with the stage fiction of *Hamlet*, for example ('Why don't I get cold when Hamlet does?'; 'who are all these other people sitting around me?' (2009: 19)), assume a very narrow interpretation of make-believe and its rules. Make-believe as a framework doesn't have to mean that we are entirely immersed in the fiction our imagination fleshes out (we don't *actually* feel cold when, as children, we pretend we're Arctic explorers), nor does it have to mean that we completely ignore the objects standing in for the figures in our fantasy. There's often, in the conventions of make-believe, an element of arbitrariness in the selection of representing objects; children will turn to whatever is on hand to act as props. And yet, just as the random objects selected from the audience in *My Arm* can seem to resonate curiously

with the characters they come to represent, the arbitrary paraphernalia of make-believe can take on its own meanings. The same thing happens in *An Oak Tree* with the device of the second actor: at first they're just pretending to be the Father without any attempt at resemblance, but as the show goes on we begin to see surprising elements of the character in their performance. At the performance in July 2015, for example, Lovett seemed visibly embarrassed during the sequence in which the Father is hypnotised to believe that he has soiled himself, while the later scenes were – at least for me – tinged with what felt like genuine grief. It's hard to know how much of this was down to Lovett's unrehearsed acting and how much of it was produced in my mind by the make-believe scenario. Also, as I've already noted, the conventions of make-believe are reflected in the formal structure of the play, which opens with the establishment of the same sort of 'rules' that children decide at the outset of their imaginary games.

As well as addressing formal concerns, there is a strong narrative and thematic grounding for Crouch's exploration of representation and transformation in *An Oak Tree*. In his notes for the play, Crouch identified his intention to 'present and examine the life of the imagination after monumental loss' (Crouch 2013: 232). This blurring of boundaries between the real and the imagined during a state of extreme grief is also nodded to by the play's epigraph, a quotation from Arthur Koestler: 'The distinction between fact and fiction is a late acquisition of rational thought – unknown to the unconscious, and largely ignored by the emotions' (Crouch 2015b: 16). We could thus think of the whole play as a representation of (or, in Rebellato's terms, metaphor for) the confused and tortured mind of a grieving parent.

Crouch has also described *An Oak Tree* as a 'metaphor with regard to the relationship of art to calamitous everyday events' (Crouch 2013: 232). Before the script itself was written, Crouch explained the narrative as one of loss and creation, considering both the Hypnotist and the Father as artists whose ability to create has been impacted upon by Claire's death. The Hypnotist is an 'artist who, as a consequence of what happens, loses his ability to create', while the Father suddenly becomes an artist when he transforms the oak tree by the side of the road into his daughter (*Ibid.*). The Father, in Crouch's opinion, is 'redeemed by art' through this act (Crouch quoted in Bottoms 2009: 76), but the impression of art and its relationship to life that we are left with remains decidedly ambiguous. Can art be truly transformative (and transforming), or does it just furnish us with comforting illusions? For me, this question is never fully answered by *An Oak Tree*. Instead, it lingers after the performance, along with the many other questions that the play implicitly raises.

As the play goes on, meanwhile, uncertainty multiplies. It becomes less and less clear where 'character' ends and 'performer' begins – while both, of course, remain roles created and scripted by the text. Following an apology from the Hypnotist, for instance, the Father reassures him with the words 'It's fine. It's not really me' (Crouch 2015b: 57), reminding us of the artificial situation created by the play. There are further slippages in the following scene, in which the Father character oscillates between his role in the fictional narrative and his role in the stage scenario. His words 'You said we could stop if I wasn't enjoying it' (63) seem to place him firmly back in the role of reluctant second performer, but moments later he is speaking again as a bereaved

parent, adding poignance as well as ambiguity to his line 'I want it to stop' (*Ibid.*). Shortly afterwards, the stage play and the Hypnotist's show seem to fold into one another, as a conversation that initially appears to be about the experience of performing on stage unprepared ('Is it how you imagined it?' asks the Hypnotist) bleeds into a conversation about the fictional Hypnotist's act (65–66). At this point the previous speech patterns of the show – which have involved the Hypnotist/Crouch giving instructions – are reversed as the Father tells the Hypnotist 'Say "I'm sorry"' (66). For an audience, of course, there is the further uncertainty of how much of the second actor's behaviour is 'real' and how much is performed. As Bottoms notes, 'One of the sources of intrigue for spectators lies in trying to detect the second actor's actual responses to her or his situations' (2009: 71). When are they simply reacting in the moment and when are they 'in character'?

Uncertainty, like contradiction, is something that Crouch tries to cultivate in his work, though he is careful to distinguish between uncertainty and confusion:

> I am interested in that word 'uncertainty' – nothing is definite: so I am not definitely 'me' and I am not definitely 'not me'. I am interested in it because uncertainty enables an audience to be open and allows questions to materialise that might not otherwise materialise if there was certainty. This is different to confusion. I try not to confuse. In *An Oak Tree* I am very precise in delineating when I am in character and when I am not in character. That then generates a whole set of bigger questions through a knowingness on the audience's part that there is uncertainty or there is a vacillation

between these two states – the states of 'real' me and 'performed' me.

(Crouch quoted in Ilter 2011: 398–399)

As Crouch acknowledges, this uncertainty – much like inde-terminacy – requires some containing boundaries. Belloli suggests that Crouch's use of the objects selected from the audience at the beginning of *My Arm* to represent figures in the narrative engineers a 'transitional state' at the outset in order to establish 'tentative "rules"', within which audience members can then freely interpret (Belloli 2016: 18). Right from the start it is made clear that one thing can stand in for another (a keyring for a parent, say) with no resemblance whatsoever. These 'rules' of transformation thus provide an antidote of sorts to the uncertainty elsewhere. Crouch him-self has talked about this need to provide props – both literal and psychological – for audiences. While developing *An Oak Tree*, he suggested that 'something needs to be put in place as a substitute/representative for something else. (This is easier than just "imagining" from nothing.) A physical support for transubstantiation' (Crouch 2013: 234). This thinking is what ultimately led to the inclusion of the second actor, onto whom audiences can project their imagined versions of the Father.

Alongside discussions of contradiction and uncertainty, there is also a vocabulary of openness that surrounds the crea-tion of Crouch's work. Smith, for example, discusses how he and the rest of the creative team 'guide the play to production trying to keep things open, in the hope that the audience can come in and meet the work with openness too' (2011: 410). The examples I've given in this chapter suggest just some of the ways in which Crouch and his collaborators 'keep things

open' for audiences. The script of *An Oak Tree*, which Lane has described as 'an open performance score', could thus be considered an 'open text' (2010: 139). Precisely how an open text is defined, however, is far from straightforward. Theoretically, all texts for theatre are 'open' in that they cannot foreclose possibilities in performance. The same, indeed, can be argued of all works of art, as Umberto Eco influentially suggested in his book *The Open Work*. Eco proposed that any work of art is both closed, in that it is 'a balanced and organic whole', and open, in that it invites 'countless different interpretations which do not impinge on its unadulterable specificity' (1989: 4).

With reference to Eco, Bishop suggests critically that formal openness and 'resistan[ce] to closure' have become familiar characteristics of contemporary art (2004: 52). She sees in these characteristics a misreading of poststructuralist theory (a school of thought to which Eco can be seen to belong) and its shift of emphasis from the author to the reader, most memorably captured in Roland Barthes's famous essay 'The Death of the Author' (1967). Bishop observes that in much contemporary art 'rather than the *interpretations* of a work of art being open to continual reassessment, the work of art *itself* is argued to be in perpetual flux' (2004: 52, original emphasis). This sort of effort towards openness on the part of artists, therefore, could be seen as unnecessary, since all works of art are open to the multiple interpretations of their viewers, their meaning(s) not fixed in advance.

Yet Eco also discusses works that are open 'in a far more tangible sense' (1989: 4) – a category into which I think *An Oak Tree* might fit. In Eco's analysis, these open works have a somewhat ambivalent relationship with the author's intention,

once again revealing the interplay of determinacy and inde-
terminacy. While open works invite the involvement of their
performers and spectators, different performances are 'to be
seen as the actualization of a series of consequences whose
premises are firmly rooted in the original data *provided by the
author*' (19, my emphasis). Again there is this idea of mutability
within defined limits. This speaks to the notion I introduced
earlier of the procedural author, and indeed White offers
another distinction that is useful for thinking about open-
ness in performance texts. He states that the production of
texts is 'a matter of creating gaps for readers and spectators
to fill, though often this might be an entirely unconscious
element of the creative process. A procedural author creates
gaps of a different kind' (2013: 59). In other words, while
all scripts will inevitably and necessarily contain gaps – they
'underdetermine the world', remember – the procedural
author *actively* inserts gaps within a carefully bounded struc-
ture, creating spaces to be imaginatively filled. And in crafting
blank spaces in the performance text, the procedural author
is seeking out – indeed, relying upon – the engagement and
interpretation of the audience.

The audience

From the very beginning, *An Oak Tree* demands the attention of its audience. 'Look' goes the repeated refrain of the opening scene, offering multiple invitations for us to engage our senses and foregrounding the visual qualities of the theatrical event immediately before (or at the same time as) its key transformations occur. Importantly, though, none of these transformations actually takes place on stage; instead, they occur (or, perhaps in some cases, don't occur) in the minds of spectators. According to Lane, Crouch's theatre thus 'expects the audience to invest in an act of creative *construction*, rather than creative response' (2010: 139, original emphasis).

Yet *An Oak Tree* is not, strictly speaking, an 'interactive' piece of theatre. At no point is anyone in the audience required to step on stage and 'perform'. This is, however, a possibility that is alluded to within the piece. At the very start, the second actor sits among the audience, stepping out from our midst like a volunteer at a hypnotist's show. When the scene shifts to the actual Hypnotist's show within the narrative, meanwhile, Crouch is careful to delineate the audience's role, instructing us *not* to step up when his character asks for volunteers. This

constructs the framework of our spectatorship – the 'rules' – but also nods towards other possibilities. We could, if we really wanted to, intervene in the performance.

A similar and more explicitly signalled possibility was made clear in Crouch's later work *The Author* (which could just as easily have been titled 'The Audience'). This show took place without a stage: the audience were arranged in two banks facing one another, from within which the dispersed actors talked about the damaging experience of working on a fictional play (written by 'Tim Crouch') about conflict and abuse. At each performance, a plant would walk out near the beginning of the show, giving other audience members the 'permission' to do the same and thus transforming the choice to remain in the auditorium into an active decision. Crouch foregrounded an option (walking out) that is always already there but that is rarely taken up, in the process shifting the experience of spectators. Suddenly, audience members were *choosing* to listen to the atrocities described by the performers, becoming complicit in the action of the play.

Another way in which Crouch manipulates our position as audience members in *An Oak Tree* is to shift the time in which the narrative he is telling takes place, moving it out of the frame of the here-and-now theatrical event. The story is happening 'this time next year, say', in a pub at which we represent the inebriated punters (2015b: 22). Thus, as Bottoms notes, spectators 'are cast as "characters" in the play but simultaneously reminded of their non-coincidence with the spectators they represent' (2009: 66) – much like the 'non-coincidence' of the second actor and the character of the Father. This dual temporal positioning – we are both in the theatre, now, before the terrible events of the play, as well as in that fictional pub in a year's time – has the further effect of making spectators feel at once in the know and helpless.

When the second actor (speaking 'out of character') later asks of Claire's death 'Is there nothing we can do to stop it happening?' (Crouch 2015b: 57), the audience might as well be asking the same. Having established the involved but limited role of spectators, Crouch then says to his fellow performer 'That's them dealt with!' (23). This line has a slightly dismissive tone to it, but it also opens up our engagement with the show as audience members. The parameters thus established, we are free to interpret the play as we wish within them – or even, should we choose, to challenge them.

Crouch's work has often been discussed in terms of the relationships it creates with its audiences. While his plays are not considered interactive or immersive, the place of the audience in his performances is always carefully thought through. In *My Arm*, spectators are drawn into the action by donating their possessions to the performance; the second act of *ENGLAND* casts the audience in the (unspeaking) role of the widow of the man whose heart has been donated to the play's protagonist; *The Author* takes place in the very midst of spectators. 'The audience is absolutely fundamental to my thinking,' Crouch has said. 'They provoke and they incubate the form – they hatch the form' (Love 2014: 25). In *An Oak Tree* specifically, Crouch insists that 'there is a democratising going on' (Crouch quoted in Ilter 2011: 400), particularly through the use of the second actor, whose lack of preparation reduces the distance between them and the spectators. Another effect of the second, unrehearsed performer, according to Crouch, is that it 'makes an audience more aware of their "audience-ness" and makes an actor more aware of their "actor-ness"' (*Ibid.*). By exposing the components of the theatrical event, Crouch asks – and gets us to ask – implicit questions about those components, including the position of the audience.

We should be careful, though, about making assumptions or coming to hasty conclusions about audiences. Indeed, it might be asked who this 'we' I keep referring to actually is. We – and by 'we' this time I mean the rather limited 'we' of theatre scholars – have a tendency to lump together the collective 'we' of the audience, both in lazily including imagined readers and spectators in our mode of written address (guilty as charged) and in thinking of and referring to audience members as an indistinct, undifferentiated mass.

As pointed out by both Susan Bennett in her seminal study *Theatre Audiences* (1997), and later by Helen Freshwater in *Theatre & Audience* (2009), audiences have been surprisingly neglected by theatre scholarship. Freshwater notes that 'the polemic which surrounds audiences – and the concerns and anxieties which have been projected onto them from both outside and inside the theatre – seem to be generated by a complex mix of hope, frustration, and disgust' (2009: 2). The presence of an audience at the live event creates the much-valued potential for collective emotion and empowerment, yet audiences have frequently been regarded with a certain distaste by both academics and artists. Often, theatre-makers view the audience as a collective body to be educated or offended, while very little effort has been expended soliciting the opinions and reactions of actual, individual spectators. As Freshwater points out,

> The common tendency to refer to an audience as 'it' and, by extension, to think of this 'it' as a single entity, or a collective, risks obscuring the multiple contingencies of subjective response, context, and environment which condition an individual's interpretation of a particular performance event.
>
> (2009: 5)

She also warns that the idea that audience participation is somehow inherently empowering is now a core and often unchallenged belief for many theatre and performance scholars. Like Freshwater, we (whoever we are) should challenge this easy assumption. Just as liveness is not necessarily radical or resistant to commodification, participation does not necessarily have any profound personal or political effects for audience members.

The view of the audience in dominant critiques of conventional theatre, according to Jacques Rancière's influential analysis, is that 'To be a spectator is to be separated from both the capacity to know and the power to act' (2011: 2). Many theatre practitioners who, over the last few decades, have sought to involve and 'activate' the audience proceed from an assumption that to be an audience member is to be passive. For Rancière, by contrast, the true emancipation of the spectator 'begins when we challenge the opposition between viewing and acting' (13). Crouch's work can arguably be seen to mount this challenge. Indeed, his first collected volume of plays takes as its epigraph a significant passage from Rancière's book *The Emancipated Spectator*:

> a new adventure in a new idiom … calls for spectators who are active interpreters, who render their own translation, who appropriate the story for themselves, and who ultimately make their own story out of it. An emancipated community is in fact a community of storytellers and translators.
>
> (Rancière quoted in Crouch 2011a: 6)

In Crouch's shows, very little (if any) physical or verbal participation is asked of audience members, but neither are they

assumed to be passive viewers. Their imaginative involvement and 'co-authorship' are necessary in order for the work to mean anything. As Crouch himself puts it, 'I minimalize what's happening on stage so I can maximize what's happening in the audience' (Crouch quoted in Bottoms 2009: 69). This again recalls Rancière's theory. Rejecting 'the transmission of the artist's knowledge or inspiration to the spectator' (2011: 15), Rancière instead insists upon the importance of 'the third thing, that is owned by no one, but which subsists between them, excluding any uniform transmission, any identity of cause and effect' (*Ibid.*). The theatre-maker is thus likened to the ignorant schoolmaster, who does not teach the uninformed student from a position of knowledge, but instead embarks with them on a journey in pursuit of that 'third thing'.

Could Crouch be seen as one such ignorant schoolmaster, who 'does not teach his pupils his knowledge, but orders them to venture into the forest of things and signs' (Rancière 2011: 11)? While Crouch's work itself seems to proceed from Rancière's conclusions about audiences, assuming the active imaginative and interpretive involvement of viewers, the problem is that 'the vocabulary utilised for expressing Crouch's practice is decidedly anti-Rancièrean' (Delgado-García 2014: 72). As Delgado-García points out, Crouch's theatrical devices are typically 'presented as part of a devolutionary scheme, returning part of the creative work to the otherwise inactive spectators', and therefore sustaining the very narrative that Rancière explicitly critiques (2014: 73). Audiences, in Rancière's terms, do not need to have interpretive power devolved to them because they are already actively interpreting whatever they see on stage. What's more, like the disavowals of authorship addressed in Chapter 2, applications

of Rancièrean theory to Crouch's work are in danger of understating or concealing the level of control Crouch has over the performance – no matter how 'emancipated' his audiences may be.

Alongside this potentially problematic rhetoric of democracy and engagement, the treatment of the audience in Crouch's work is typically couched in a vocabulary of care. Smith writes, for example, about 'want[ing] to make sure the audience feels included' and explains 'how we do this by gently taking away, removing and revealing things, and sometimes putting them in different places' (2011: 412). The emphasis on gentleness here feels particularly significant. While Crouch and his collaborators are keen on challenging audiences, the way in which they do this is concerned with simultaneously caring for spectators. Establishing (at least partially) the rules of engagement, as already discussed, is a further aspect of this care. Of course, enacting care in this way requires Crouch and his collaborators to strengthen aspects of their control over the performance, setting up a tension in the work between care on the one hand and freedom and empowerment on the other.

Another characteristic of Crouch's work, which errs more on the side of freedom, is the leaving of spaces for the audience to fill. At the start of Scene 6 in *An Oak Tree*, for instance, there is a pause of silent co-presence as Crouch briefly exits the stage and we are left alone with the second performer. This recalls a scene in *My Arm* in which, following an anecdote about a year in the protagonist's childhood during which he didn't speak, Crouch maintains a silence 'far longer than is bearable' (2011a: 27). What these wordless pauses offer is time and space for the event to settle in audience members' minds, as well as room for spectators to imaginatively flesh out the event. A further example of this is at the end of *The Author*,

which concludes with the stage direction: '*The houselights are on. The doors to the theatre are open*' (Crouch 2011a: 203). There is thus no conventional cue that the performance has ended, giving audience members as much time as they need to process the events of the play. Typically, there was no applause at the end of the show – a mark, perhaps, of its deep impact on spectators and the need for reflection that it created.

Openness, though, allows for a wide variety of responses. Therefore audiences are, potentially, both galvanised and disenfranchised by Crouch's performances. Despite all the care inscribed in the process of Crouch and his collaborators, there remain potential problems with the ways in which they engage the audience. This was made clearest, perhaps, during performances of *The Author*. Though it was popular and widely acclaimed, the play also provoked multiple walkouts, as well as verbal threats towards Crouch. For many audience members it was a disturbing and upsetting experience; some even considered the script's conjuring of images of abuse in the minds of spectators an abuse in itself and saw themselves as passive victims rather than engaged, empowered observers. These negative reactions throughout the play's run prompted big ethical questions for Crouch and his team: Crouch has described *The Author* as 'a shared responsibility to be handled with extreme care', yet despite the care expended throughout the project he was still left worrying about its ethical implications after it had finished touring (2011b: 421). The conclusion Crouch eventually reached was that the play's rules 'require a degree of collective self-determinacy not usually expected in a theatre audience' – a challenge to audiences that he was ultimately unapologetic about (422).

Goode suggests that what Crouch requires from his audiences is 'a kind of precision: he needs them to be alert to

what's happening here-and-now' (2015: 242). This attitude towards the audience, according to Goode, 'can give rise to situations of unusual volatility' (*Ibid*.), in turn asking questions of the ethical responsibility of the theatre-maker. Goode is thinking mainly about *The Author*, in which he appeared during its controversial run at the Traverse Theatre in Edinburgh, but I think similar questions can also be applied to *An Oak Tree*. By demanding from the audience an enhanced alertness and a deep imaginative investment in a narrative that, while not as disturbing as *The Author*, nonetheless revolves around trauma, Crouch creates the potential for harm and – to borrow Goode's word – volatility. During the making of the show, Crouch anticipated that he would be 'accused of manipulating ideas and emotion' (Crouch 2013: 242). From a cynical perspective, *An Oak Tree* opportunistically and distastefully uses themes of death and bereavement as tools in an intellectual exercise. Incidentally, I do not believe that this is the case, but the personal backgrounds of different audience members (how, for example, would the play be experienced by a spectator who had lost a child?) have the potential to shift its meaning.

The affective impact of *An Oak Tree* on audiences is thus not to be disregarded or underestimated. While on reflection the play invites philosophical and aesthetic musings, in the moment of viewing it is surprisingly emotive. The final two scenes in particular have the potential to be genuinely heartbreaking, despite the fact that any attempt at realistic representation is decisively abandoned. When we are invited to see (imaginatively, rather than visually) the Father by the roadside with his wife, both his stubborn insistence on his dead daughter's presence in the form of the oak tree and Dawn's despairing, grief-ridden refusal to see what he sees

are devastating. The straightforward yet somehow poetic description of Claire's final moments in the concluding scene, meanwhile, is incredibly poignant in its ambiguous evocation of both death and reawakening through the language of hypnotism ('When I say sleep, everything stops ... When you open your eyes' (Crouch 2015b: 69)). At the end of the penultimate scene, referring back to earlier in his act, the Hypnotist tells the Father that 'There wasn't really a piano' (66). In spite of this, though, the Father persistently believes that he did indeed play the piano – 'I really played it', he says (*Ibid.*). This unexpectedly moving exchange might as well be a metaphor for the way in which we willingly subscribe to stage fictions – even those fictions, like Crouch's, which have been exposed. As audience members, we are (or at least I am) still inclined – perhaps even more inclined – to become emotionally invested in the narrative.

Story, for Crouch, remains crucial. In his early notes on *An Oak Tree*, he insisted: 'We must test the story to confirm that when it is told simply that it will contain all the other stuff' – the 'other stuff' being the play's formal ideas about art and representation (Crouch 2013: 213). And at the core of the story is emotion. Crouch has said that the play's epigraph from Koestler 'points at where I hope my work resides in an audience – as much in their hearts as in their heads' (Vile 2015). This emotional aspect of *An Oak Tree* arguably makes the play more powerful – in its formal and philosophical concerns as well in the conveying of its narrative. Bottoms points out that while gallery visitors looking at Craig-Martin's artwork are unlikely to fully visualise the 'oak tree' that he has put on display, Crouch's audiences do often become deeply emotionally involved with the narrative of the performance despite its refusal to imitate what it represents, suggesting that

it is the emotional impact of theatre that makes its 'perceptual fields of force' more powerful than those of the gallery (Bottoms 2009: 66). As Bottoms puts it, 'Spectators take the information they are given, partial and contradictory as it is, and fill out the perceptual and emotional landscape through an investment that, because personal, makes the material all the more intensely felt' (*Ibid.*).

This points again to a thread that connects the preceding pages: the relationship between closure and openness, determinacy and indeterminacy, restriction and freedom, certainty and ambiguity. For the conceptual artists who influenced and inspired Crouch, the opening up of experiences and ideas to viewers was central to the challenge they posed to the art establishment, while their art itself often displayed the witty manipulation of its creators. As a procedural author, meanwhile, Crouch – like the Fluxus artists – structures events that cultivate indeterminacy within carefully determined limits. In exploring the idea of one thing being given by another thing, *An Oak Tree* likewise plays with the balance of certainty and uncertainty, using multiple and sometimes contradictory layers of representation to provide an opening for the audience's interpretations. Finally, the imaginative, interpretive and emotional experiences of audience members are integral to *An Oak Tree*, in a sense completing it while at the same time opening it to a whole series of new meanings.

Throughout *An Oak Tree*, Crouch specifies the repeated playing of the Aria from Bach's Goldberg Variations, with very particular instructions about how it should be heard: 'It is a flawed rendition: faltering but ambitious, failing to resolve until the very end of the play' (2015b: 18). This description mirrors the dramaturgy of the play. It is a piece that builds in its own failures and imperfections, generating

theatrical representations that will be inevitably 'flawed', at
least by the standards of mainstream, conventional theatre.
At the same time, it is exhilaratingly ambitious in the ideas
it addresses – ideas about art, loss, creation, representation,
transformation and the very condition of living and dying.
And it fails – or, rather, chooses to fail – to resolve itself for
audiences, reaching only an ambiguous form of closure at
its conclusion.

Bibliography

Belloli, Jack (2016). 'Tim Crouch's Transferable Skills: Textual Revision as Distributed Determination in *My Arm* and *The Author*'. *Platform*, 10(1), pp. 10–28.

Bennett, Susan (1997). *Theatre Audiences: A Theory of Production and Reception*. Second edition. London and New York: Routledge.

Bishop, Claire (2004). 'Antagonism and Relational Aesthetics'. *October*, 110, pp. 51–79.

Bottoms, Stephens (2009). 'Authorizing the Audience: The Conceptual Drama of Tim Crouch'. *Performance Research*, 14(1), pp. 65–76.

Bottoms, Stephens (2011a). 'Introduction'. In *Tim Crouch. Plays One*. London: Oberon Books, pp. 11–20.

Bottoms, Stephens (2011b). 'Materialising the Audience: Tim Crouch's Sight Specifics in *ENGLAND* and *The Author*'. *Contemporary Theatre Review*, 21(4), pp. 445–463.

Bourriaud, Nicolas (2002). *Relational Aesthetics*. Trans. by Simon Pleasance and Fronza Woods with the participation of Mathieu Copeland. Dijon, France: Les Presse Du Réel.

Cage, John (1961). *Silence: Lectures and Writings*. Middletown, CT: Wesleyan University Press. Available online at: https://archive.org/stream/silencelecturesw1961cage/silencelecturesw1961cage_djvu.txt (accessed 7 August 2016).

Craig-Martin, Michael (1973). *An Oak Tree*.

Craig-Martin, Michael (2001). *Michael Craig-Martin: Landscapes.* Exhibition catalogue. Dublin: Douglas Hyde Gallery.

Crouch, Tim (2011a). *Plays One.* London: Oberon Books.

Crouch, Tim (2011b). '*The Author.* Response and Responsibility'. *Contemporary Theatre Review*, 21(4), pp. 416–422.

Crouch, Tim (2013). 'Notes on *An Oak Tree*'. In Dan Rebellato (ed.), *Modern British Playwriting 2000–2009: Voices, Documents, New Interpretations.* London: Methuen Drama, pp. 230–243.

Crouch, Tim (2014). 'The Theatre of Reality … and Avoiding the Stage's Kiss of Death'. *Guardian.* 18 June. Available online at: www.theguardian.com/stage/2014/jun/18/theatre-reality-adler-and-gibb-tim-crouch-playwright (accessed 18 October 2016).

Crouch, Tim (2015a). *Are We On the Same Page? Approaches to Text and Performance.* Royal Holloway University of London. 26 September. Author's conference transcript.

Crouch, Tim (2015b). *An Oak Tree.* 10th anniversary edition. London: Oberon Books.

Delgado-García, Cristina (2014). 'Dematerialised Political and Theatrical Legacies: Rethinking the Roots and Influences of Tim Crouch's Work'. *Platform*, 8(1), pp. 69–85.

Eco, Umberto (1989). *The Open Work.* Trans. by Anna Cancogni. London: Hutchinson Radius.

Elia, Miriam (2015). *We Go to the Gallery.* London: Miriam Elia.

Freshwater, Helen (2009). *Theatre & Audience.* Basingstoke: Palgrave Macmillan.

Fried, Michael (1998). 'Art and Objecthood'. In Michael Fried. *Art and Objecthood: Essays and Reviews.* Chicago: University of Chicago Press.

Gillinson, Miriam (2015). 'Tim Crouch: Bare Stages, Extraordinary Transformations'. *Exeunt Magazine.* 15 June. Available online at: http://exeuntmagazine.com/features/tim-crouch-bare-stages-extraordinary-transformations/ (accessed 4 November 2015).

Goldberg, Roselee (1988). *Performance Art: From Futurism to the Present.* Revised and enlarged edition. New York: Harry N. Abrams.

Goode, Chris (2015). *The Forest and the Field.* London: Oberon Books.

Hoffman, Beth (2009). 'Radicalism and the Theatre in Genealogies of Live Art'. *Performance Research*, 14(1), pp. 95–105.

Ilter, Seda (2011). '"A Process of Transformation": Tim Crouch on *My Arm*'. *Contemporary Theatre Review*, 21(4), pp. 394–404.

Jackson, Shannon (2011). *Social Works: Performing Art, Supporting Publics*. New York: Routledge.

Lane, David (2010). 'A Dramaturg's Perspective: Looking to the Future of Script Development'. *Studies in Theatre and Performance*, 30(1), pp. 127–141.

LeWitt, Sol (1967). 'Paragraphs on Conceptual Art'. *Artforum*, 5(10), pp. 79–83.

Live Art Development Agency (2016). *What is Live Art?* Available online at: www.thisisliveart.co.uk/about/what-is-live-art/ (accessed 27 July 2016).

Love, Catherine (2014). 'The Big Interview: Tim Crouch'. *The Stage*. 12 June, pp. 24–25.

Mansfield, Susan (2010). 'Interview: Tim Crouch – Theatre Director'. *The Scotsman*. 21 June. Available online at: www.scotsman.com/lifestyle/interview-tim-crouch-theatre-director-1-820005 (accessed 4 August 2016).

Morin, Emilie (2011). '"Look Again": Indeterminacy and Contemporary British Drama'. *New Theatre Quarterly*, 27(1), pp. 71–85.

O'Doherty, Brian (1999). *Inside the White Cube: The Ideology of the Gallery Space*. Expanded edition. Berkeley and Los Angeles: University of California Press.

Perry, Grayson (2013). 'Beating the Bounds'. *Reith Lectures 2013: Playing to the Gallery*. Radio 4 Transcript.

Phelan, Peggy (1993). *Unmarked: The Politics of Performance*. London and New York: Routledge.

Radosavljević, Duška (2013). *Theatre-Making: Interplay Between Text and Performance in the 21st Century*. Basingstoke: Palgrave Macmillan.

Rancière, Jacques (2011). *The Emancipated Spectator*. London: Verso Books.

Rebellato, Dan (2009). 'When We Talk of Horses: Or, What Do We See When We See a Play?'. *Performance Research*, 14(1), pp. 17–28.

Rebellato, Dan (2013a) 'Exit the Author'. In Vicky Angelaki (ed.). *Contemporary British Theatre: Breaking New Ground*. Basingstoke: Palgrave Macmillan, pp. 9–31.

Rebellato, Dan (2013b) 'Tim Crouch'. In Dan Rebellato (ed.). *Modern British Playwriting 2000–2009: Voices, Documents, New Interpretations*. London: Methuen Drama, pp. 125–144.

Rebellato, Dan (2015) 'Introduction'. In Tim Crouch. *An Oak Tree*. 10th anniversary edition. London: Oberon Books, pp. 5–8.

Roche, Henri-Pierre, Wood, Beatrice and Duchamp, Marcel (1917). *Blindman*. 2. New York. Available online at: http://sdrc.lib.uiowa.edu/dada/blindman/2/05.htm (accessed 4 November 2016).

Smith, a (2011). 'Gentle Acts of Removal, Replacement and Reduction: Considering the Audience in Co-Directing the Work of Tim Crouch'. *Contemporary Theatre Review*, 21(4), pp. 410–415.

Vile, Gareth (2015). 'Oaken Dramaturgy: Tim Crouch'. *The Vile Blog*. 30 July. Available online at: http://vilearts.blogspot.co.uk/2015/07/oaken-dramaturgy-tim-crouch.html (accessed 4 August 2016).

White, Gareth (2013). *Audience Participation in Theatre: Aesthetics of the Invitation*. Basingstoke: Palgrave Macmillan.

Index